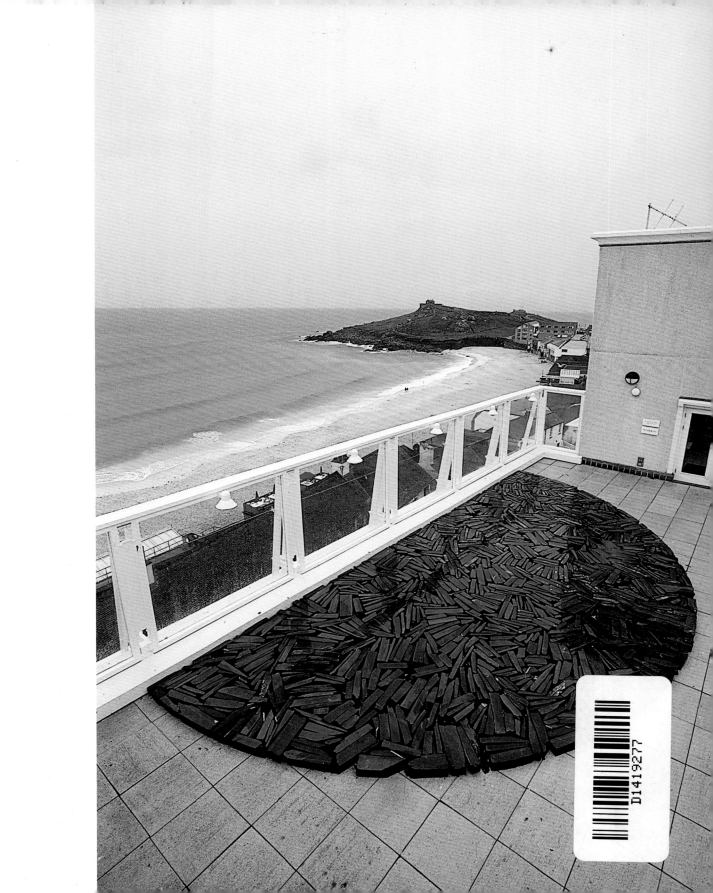

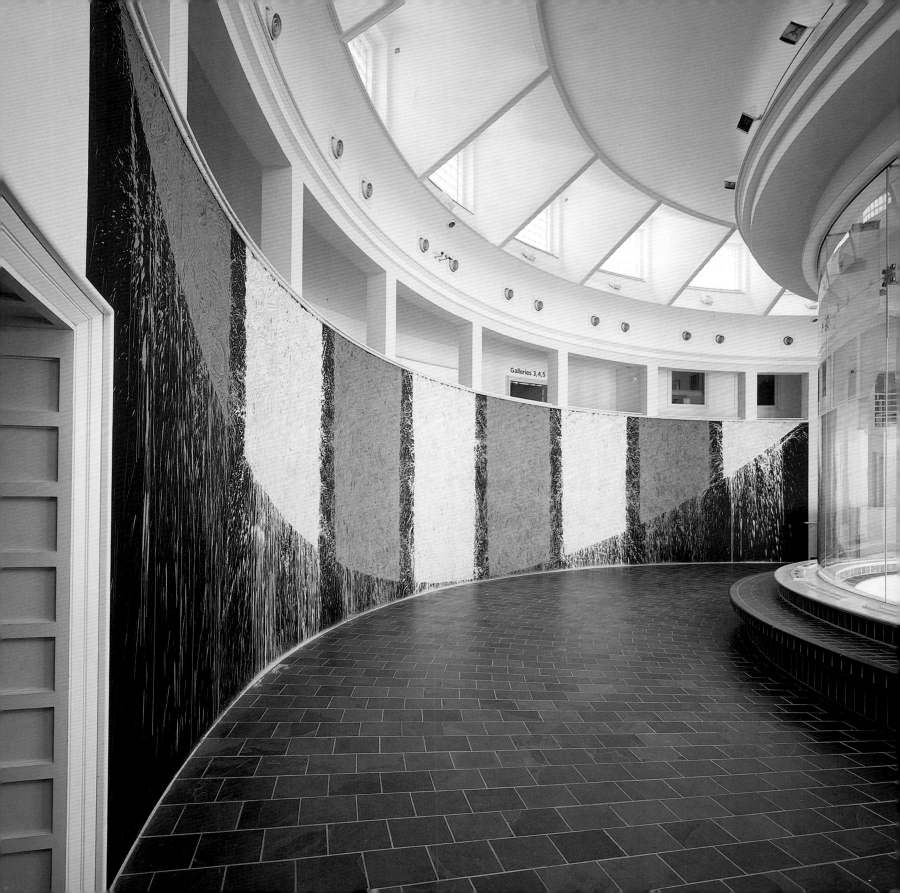

LONG

WORLD

St IVES
TATE

Published to accompany
the exhibition at Tate St Ives
13 July – 13 October 2002

Supported by
The Henry Moore Foundation

First published 2002 by
Tate St Ives
Porthmeor Beach
St Ives, Cornwall
TR26 1TG
www.tate.org.uk

Edited by
Susan Daniel-McElroy,
Andrew Dalton and Peter Evans

Photography
Bob Berry

Design
Groundwork, Skipton

Print + repro
Vision Colour Print, Leeds

Printed in England

British Library Cataloguing in
Publication Data
A catalogue record for this book is
available from the British Library

ISBN 1–85437–450–8 (pbk)

Front and back cover
and pp 1, 7, 28, 34, 39
Slate Atlantic 2002

Front flap
Porthmeor Arc 2002 (detail)

Frontispiece and p 38
Porthmeor Arc 2002

Opposite and pp 37, 41–43
Cornish Driftwood 2002
River Avon mud and/or
Cornish china clay fingerprints

CONTENTS

SLATE ATLANTIC – EARTH – FOLLOWING AN IDEA – A MOVING WORLD

The works of Richard Long seem to fall into two categories. Works which feed the mind and imagination such as his walks in wilderness landscapes or road walks which are sometimes planned to coincide with, or measure cosmic phenomena and events in relation to a particular journey or place. Long's sculpture, on the other hand, almost entirely feed the senses with his attention to material, form, scale, colour and texture.

Richard Long has been testing the boundaries of art since the late 1960s with walks recorded by texts, or photo works of his sculptures in the landscape, and by gallery installations using materials such as clay, pine needles, driftwood, slate, mud and stones. The intellectual beauty of walking a straight line across a landscape has inspired him to make many constructed walks through a variety of topographies and climates in locations from his beloved west country to elsewhere on five continents.

The exhibition A Moving World has been selected by the artist to use the particular architecture of Tate St Ives and articulates a physical experience of grace, lucidity and impermanence. Expressive and compelling artworks such as Porthmeor Arc and Earth, are worked in River Avon Mud and Cornish China Clay to make wall works on a monumental scale, where the subject seems to be water and gravity as much as earth. The sense of gravity is emphasised by the vitality of drips and splashes created by the speed of the artist's hand as he manipulates the watery material across the surface, only stopping when the work is complete. This temporal aspect of Long's work is an interesting revelation. Porthmeor Arc and Earth were made over a 6 hour and a 3 hour period respectively, without stopping. This very public act of creation gave us a rare insight into Long's focus and process of making.

Richard Long has stated 'I have the most profound feelings when I am walking, or touching natural materials in natural places.' Evoking these external experiences, the works at St Ives make visible the artist's energy and engagement with his materials and the forces and phenomena of nature. The archetypal line and circle have given Long freedom from a personalised or anecdotal aesthetic, but paradoxically, he states that his work is a portrait of himself in the world, his personal journey through it and the materials that he finds along the way. His work is his own footprints, as is the repetition of marks in mud and clay in the gallery are his handprints. 'My work is real, not illusory

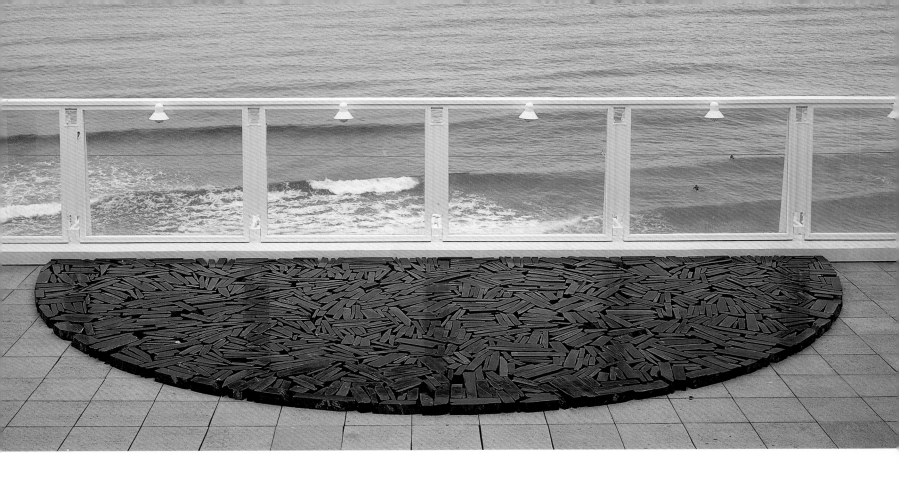

or conceptual. It is about real stones, real time, real walks. I use the world as I find it.'

Our warm thanks to Anthony d'Offay and his team for essential support in the process of making this exhibition. I am particularly grateful to Paul Moorhouse, Senior Curator, Contemporary Art, Tate, for his fine essay which brings new, eloquent and profound insights to Richard's practice. Without the support of the Henry Moore Foundation, this publication would not have been possible, and we thank the Trustees and Director Tim Llewellyn.

Finally, we are greatly indebted to Richard Long for his focus and commitment to our project and for agreeing to make new works to challenge the architecture of St Ives with skill and enthusiasm.

Susan Daniel-McElroy
Director, Tate St Ives

CROSSING STONES

A STONE FROM ALDEBURGH BEACH ON THE EAST COAST CARRIED TO ABERYSTWYTH BEACH ON THE WEST COAST
A STONE FROM ABERYSTWYTH BEACH ON THE WEST COAST CARRIED TO ALDEBURGH BEACH ON THE EAST COAST

A 626 MILE WALK IN 20 DAYS

ENGLAND WALES ENGLAND

1987

THE INTRICACY OF THE SKEIN, THE COMPLEXITY OF THE WEB
– RICHARD LONG'S ART

Always think of the universe as one living organism, with a single substance and a single soul; and observe how all things are submitted to the single perceptivity of this one whole, all are moved by its single impulse, and all play their part in the causation of every event that happens. Remark the intricacy of the skein, the complexity of the web.

(Marcus Aurelius, *Meditations*) [1]

In 1987 Richard Long made a work of art involving two stones. The size, shape and colour of these objects is not recorded but undoubtedly they were small enough to be held in the hand and light enough to be carried. At a certain, unspecified moment in that particular year, Long stood on the beach at Aldeburgh on the English east coast and, from the millions of similar pebbles there, he selected the first stone. He then set out on a journey, carrying this modest, natural relic of the Suffolk landscape.

His destination was the beach at Aberystwyth on the Welsh west coast. He walked all the way, covering a distance of over 300 miles in around ten days. We are not told what he saw and felt during his journey. It appears, however, that when he reached his destination he placed the stone he had been carrying in these new surroundings. He then picked up a different stone and reversed the process, taking it with him as he commenced the walk back to Aldeburgh. Whether he used the same route is not divulged. On his arrival at the east coast, twenty days after he last stood there, he placed the stone he had carried from Aberystwyth on the beach at Aldeburgh. Some time after the completion of this walk he then made a framed text work – *Crossing Stones* – which provides a succinct description of this activity.

It is now fifteen years since Long carried out this walk and almost certainly the two stones are no longer exactly where he left them. The weather, the tides, and endless natural movement in the landscape will have ensured that nothing at either place will have remained the same. In placing the stones Long created a fragile structure which has presumably disappeared; or, rather, it has simply returned to nature. Nevertheless,

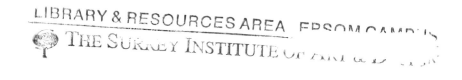

A SNOWBALL DRAWING
BRISTOL 1964

somewhere at Aldeburgh and Aberystwyth, these two stones are almost certainly still there: transplanted and assimilated; endlessly buried, exposed and covered over again by the elements; each moving imperceptibly in the orbit of their radically altered situation. For what *is* certain, is the significance that Long's intervention has had for the natural order of things.

Plucked from their former situation, the stones remain physically remote. Now, however, they are also intimately *connected* by the bonds of their shared condition. Both stones have made a unique crossing and the resulting connection between them exists in the context of the work of art which created this situation. A particular relationship between certain landscape elements has been defined by the power of an idea and its *actual* execution: nature touched lightly, yet articulated at the deepest levels. In the fertile interaction of these apparent opposites – a living human presence and the inert matter of the natural world – the intangible essence of Long's art may be glimpsed.

A MOVING WORLD

In a career that now spans more than thirty five years, Long has created a substantial and varied body of work in which the relationship between man and nature is a central, unifying concern. Taking nature both as his subject and as the source of his materials, Long's artistic ethos has always been one of direct, dynamic, physical involvement with landscape. This is evident in his earliest works, notably when in 1964 he made a drawing on the ground on the Bristol Downs simply by rolling a snowball across the snow-covered grass. The notion of impermanence entailed by this work has been an abiding principle in his subsequent interactions with nature. It was, however, the decision he took in 1967 to make sculpture out of walking which established the principal defining characteristic of Long's art and the course it has followed to the present day.

Long's first walking piece, *Ben Nevis Hitch-Hike* 1967 comprised a six-day walking and hitch-hiking journey from London to the summit of Ben Nevis and back. As shown in the related map work which provides a record of Long's route and itinerary, during the course of this trip a photograph was taken at each of six locations, each unnamed

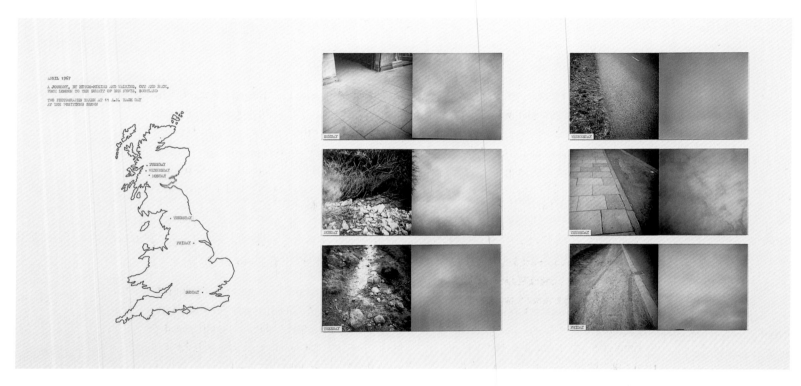

BEN NEVIS HITCH-HIKE

1967

A TEN MILE WALK

ENGLAND 1968

location being specified on an outline map of Britain by the day the photograph was taken. Even today, in a visual culture long accustomed to art being made from any material whatsoever, including pre-existing objects, there is something about a sculpture being made out of a *walk* which still challenges some deeply held assumptions. Mostly firmly rooted among these is, perhaps, the sense that – no matter what it is made of – a sculpture should at least have a physical form or attributes that can be perceived. From the outset, walking as art confounded such expectations. Since then, Long's innovations have been widely embraced as a radical redefining of the boundaries of sculpture. But, even so, it is still pertinent – and illuminating – to ask: in what sense *can* a walk be a sculpture? Indeed, how does a walk function as a work of art at all?

Part of the difficulty of accounting for such developments is that they cannot easily be accommodated within recognised art historical theories and categories. Duchamp's designation of pre-fabricated objects as works of art is the source of a major tributary running through Modernism. It has, however, limited relevance to an appreciation of Long's designation of walking as art. Duchamp's innovation – bold as it was – rests on the perception of one or more physical objects. In contrast, Long took sculpture into the domain of the immaterial: the walk comprises the movement of a body through time and space and, as such, has no permanent physical attributes. Nor can the walk as artwork be understood by reference to avant-garde art movements such as Conceptual Art whose emergence formed the backdrop to Long's own artistic development. The premium placed by conceptual artists on ideas – to the extent that their actual realisation is secondary – is completely antithetical to Long. As in the example of *Crossing Stones*, the walk itself may have no lasting physical attributes but the work could not exist if the walk had not happened.

Other approaches to these questions are needed and Long himself has provided insights. He has observed: `Walking itself has a cultural history, from Pilgrims to the wandering Japanese poets, the English Romantics and contemporary long-distance walkers.' [2] Walking is a fundamental, universal activity, the basis of locomotion through the world for human beings. But as well as being essentially practical, as Long implies it is also closely bound up with the cultures of different races throughout the

ages. Though its principal function is movement, people do not only walk to get from one place to another. Walking is a way of engaging and interacting with the world, providing the means of exposing oneself to new, changing perceptions and experiences and of acquiring an expanded awareness of our surroundings. Through such experiences, and through a deeper understanding of the places we occupy, we acquire a better understanding of our own position in the world.

Such considerations are germane to an understanding of the importance of walking in Long's art. For example, the subject of *Walking in a Moving World*, the text work that commences the present exhibition, is relativity. It describes a five-day walk undertaken by Long in Powys in 2001. It does so in terms of the artist's different physical relationships with various natural phenomena as he moves across the landscape. The text is arranged by listing these phenomena in order of the speeds at which *they* are moving, from fastest to slowest – from fleeting cloud shadows to an imperceptibly slow glacial boulder moving at geological speed. The impression conveyed is of a world in movement, never still. There is a vivid sense of *relation* between the walker's movements and his changing surroundings through the use of particular phrases – *between, into, across, through, under* and *over* – words which only have meaning in relative terms. In these ways, the underlying subject of the work is revealed: through walking the intimate connection between man and nature is revealed.

In Long's art, the walk is thus the most direct, immediate and practical way of interacting with nature. It would however be wrong to assume that this universal activity has, in an unqualified way, simply been redesignated as art. As *Crossing Stones* and *Walking in a Moving World* both demonstrate, Long's walks are considered and structured. They have a sense of purpose and a definite character. Each walk is structured, so that different elements become connected and drawn into perceivable relationships. Sometime these connections are relatively simple. In an early work such as *A Ten Mile Walk* 1968, for example, Long walked for ten miles in a straight line. As a result, distance and direction were linked. In turn, from the relationship drawn between those two properties, two specific places – the start and finish of the walk – became connected, as did all the unnamed points traversed during the walk. The walk

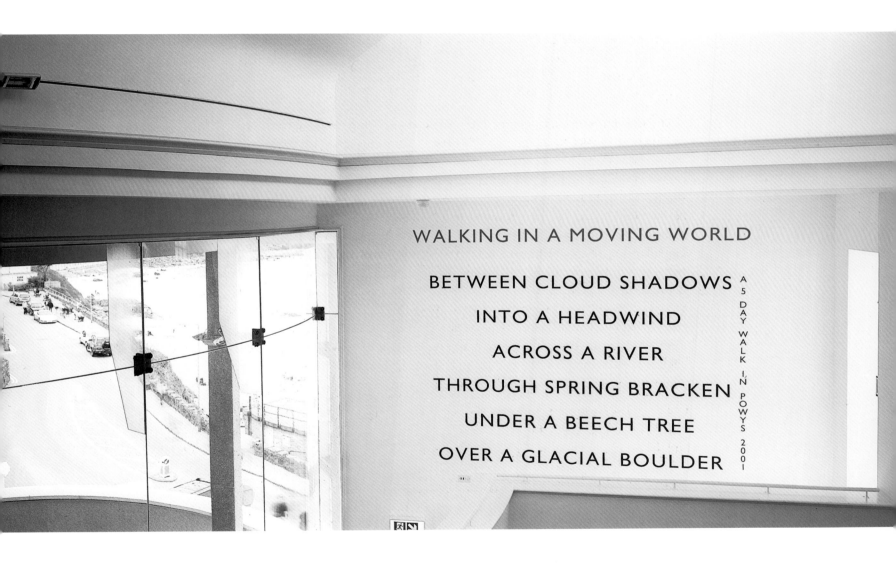

WALKING IN A MOVING WORLD

BETWEEN CLOUD SHADOWS

INTO A HEADWIND

ACROSS A RIVER

THROUGH SPRING BRACKEN

UNDER A BEECH TREE

OVER A GLACIAL BOULDER

A 5 DAY WALK IN POWYS 2001

has a structure which the related mapwork makes explicit and which the viewer can experience imaginatively.

Other walks are more complex, making subtle connections between abstract properties of time, distance, speed of walking and perception in addition to the linking of particular geographical points. These developments are evident in a walk made on Dartmoor in 1970: *For six consecutive nights I walked by compass, from east to west, the line drawn on the map. The time taken was recorded at the end of each walk.* Walking in darkness, Long paced out precisely the same route on six nights in succession. Using a compass to determine his direction, he timed himself on each occasion, noting that overall his walking time became shorter as his familiarity with the landscape at night grew and his speed increased. The walk is structured in terms of the relationships created between the artist's body, his experiences, aspects of the landscapes – and time. That the walk defines certain relationships locates it within the language used in speaking of sculpture. That these relationships do not have a material form shows Long's achievement in taking the definition of sculpture beyond the making of objects.

FOLLOWING AN IDEA

The relationship between the idea for a walk, the walk itself, and the physical evidence of the walk, is a fundamental issue in Long's art. While it is possible to identify these different components singly, it is the interaction of these components that provides the fabric of his work. It is for this reason that, as already seen, Long's art falls outside the definition of Conceptual art. The idea is vital in that it defines the structure for a walk. But the walk is equally important in that it realises the idea, actualising the structure as physical movement through time and space, so that the work of art has a *real* – if transient – existence.

The walk's lack of permanence is intimately bound up with its subject. Nature is synonymous with movement and change. In providing a vehicle for exploring these issues, it is appropriate that the walk should be in harmony with them, providing a way of making art that is also impermanent. Nevertheless, nature also shows some evidence of the changes which galvanise it, even if some of these changes are

recognisable only through a microscope. It is clear, therefore, that from the beginning, Long considered how the focus of his work – the walk – might leave a trace on the surface of the land.

His first such work was *Walking a Line* 1967. In keeping with his ethos of using means which are direct, immediate and practical, this took the form of a straight line running across a grass field: the result of repeating his steps. He then photographed the work. Simple to make and easy to describe, the implications of this piece were nevertheless profound. Essentially, its subject is the interaction of man and nature. Yet the way the work conveys this is economical, pure and appropriate. Without describing nature or adding anything superfluous, the work takes its place, temporarily, in nature – its subject and its means brought into perfect alignment. The principle of making a work of art about the meeting of man and nature by leaving a sign of that interaction is encapsulated in this work and in Long's subsequent development of that approach.

Since making *Walking a Line*, Long has made numerous other works which exist as impermanent traces of his walks, and of his physical presence in the landscape, at a range of sites and in various countries around the globe. In some cases, the connection between a walk and its physical consequences is overt. In *A Line of 164 Stones A Walk of 164 Miles* 1974, for example, Long walked across Ireland. During the course of his journey he stopped after every mile and placed a nearby stone on whichever road he was walking along. The resulting sculpture thus comprised 164 separate stones and spanned a distance of 164 miles – a sinuous, skein-like structure, from coast to coast, which tracked his movement across the landscape. In other works the connection with the walk is less obvious. Using stones, sticks, dust, mud, water – whatever is locally available – Long has made sculptures at certain points during the course of particular walks. These constructions belong to a restricted vocabulary of elemental shapes: lines, circles, spirals, crosses and elipses. Sometimes they are formed by drawing together individual elements so that they form a shape. On other occasions, Long has removed elements – for example by kicking stones aside – to expose a shape on the surface of the ground.

Much has been made by commentators about the significance of these shapes. Allusions have been made to the way they echo forms in nature and also to their

A LINE OF 164 STONES
A WALK OF 164 MILES

A WALK ACROSS IRELAND, PLACING A NEARBY STONE ON THE ROAD AT EVERY MILE ALONG THE WAY.

CLARE	49 STONES
TIPPERARY	38 STONES
KILKENNY	27 STONES
LEIX	9 STONES
CARLOW	20 STONES
WICKLOW	21 STONES

1974

1449 STONES AT 1449 FEET

1449 TINNER'S STONES PLACED ON DARTMOOR AT 1449 FEET ABOVE SEA LEVEL

ENGLAND 1979

universal qualities in the way they cut across different cultures and periods. Such interpretations can certainly be accommodated within the broader context of Long's work. Arguably, however, the principal significance of these sculptures lies elsewhere. For example, in a work such as *1449 stones at 1449 Feet*, a sculpture made on Dartmoor in 1979, there is little sense of any shape in particular. Instead, the stones are piled amorphously and it is their number and location that are important. As the title implies, the structure makes a connection between the precise number of stones that comprise the work and the exact height at which it is situated.

What this work has in common with those which are formally more pure – such as the circles or lines – is the way that both provide evidence of the artist's presence in a particular place. As with the walks, there is an inescapable sense of structure. This structure can exist in terms of the relationships drawn between invisible qualities of measurement, as in *1449 Stones at 1449 Feet*. Alternatively, the connections made can be physical and primarily visual, as in the grouping of stones in one of the circles. In both cases, what is pre-eminently significant is the fact of *arrangement*: the connecting of different elements. In Long's work, arrangement arises from the meeting of human characteristics with the natural materials of the world. As such it is an index – a trace – of the relation between man and nature.

The sculptures in the landscape are therefore a vital aspect of Long's art, making visible the relationship that is its central subject. To a large extent, however, these works are not seen by anyone apart from the artist and others who happen to come upon them. Not only are they temporary sculptures which begin the process of their assimilation back into nature as soon as the artist leaves them, they are also frequently in remote locations. In seeking to record the walks and sculptures, and to make them more widely visible, Long has adopted other strategies – in the form of maps, photographs and text – which can also be seen in terms of following, or providing the trace of, an idea.

Such strategies are apparent in Long's work almost from the beginning. For example, the track left by the snowball on Bristol Downs in 1964 was shortlived but the related photograph preserves a trace of this work's brief existence. Three years later – in *Ben Nevis Hitch Hike* 1967 – the walk was documented by photographs, a map and words

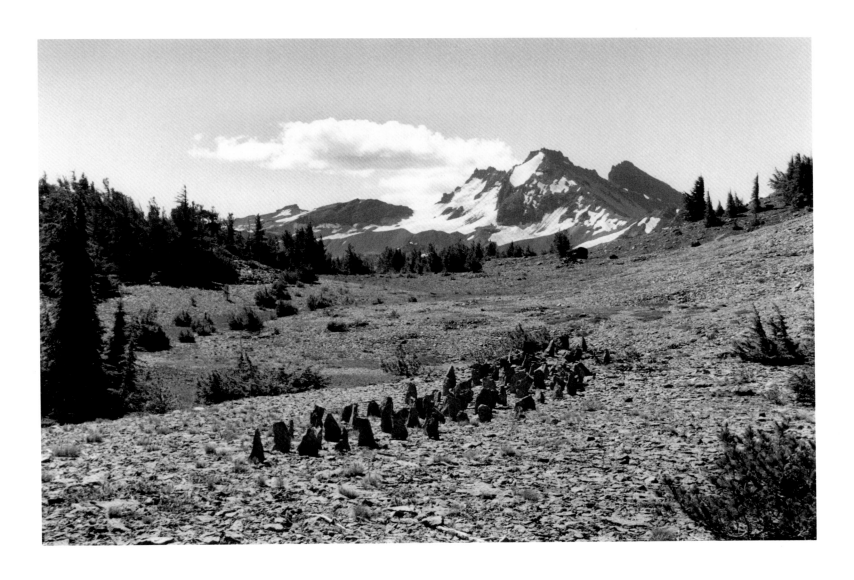

CLOUD MOUNTAIN STONES

A 15 DAY WALK IN THE THREE SISTERS WILDERNESS

OREGON 2001

used in combination. Long continued to use these elements in his subsequent work, sometimes independently, sometimes in different combinations. In Long's work, maps, photographs and words relate to a walk or sculpture as a footprint does to a foot. As signs, they are partial, revealing aspects of the experience that caused them; but they also provide – in their different ways – sufficient information for the viewer to *imagine* the circumstances which led to their creation.

This is most evident in the text works. Since 1977, Long has used words less as factual or descriptive annotations to photographs or maps and more as a discrete way of working in its own right. As the selection of text works in the present exhibition demonstrates, their role is to tell the story of individual walks. However, they take the form of words or phrases – notably observations, feelings, experiences, place-names, measurements of time, duration, number and distance – drawn into arrangements whose structure is rarely a narrative one. Neither poetry nor straightforward prose, the structure of such texts is closer to sculpture than to literature, arising from the connection and inter-relation of words, ideas and experiences. For example, *Walking to a Solar Eclipse* 1999, traces a walk in which destination, duration and distance are aligned with a certain momentary relationship between the sun, the moon and the earth. *Sunrise Circle* 1998 also evokes in words the meeting of a human gesture with certain natural forces: in this case the fleeting connection made between the rising of the sun and a hand drawing a circle in snow on a mountaintop in Ecuador.

In this way, the text works – like the photographs and maps – `feed the imagination',[3] as Long puts it. They follow an idea, evoking its realisation as a walk or as a sculpture made during a walk. In the absence of these phenomena, words, cartographic symbols and images made with a camera are the traces that remain.

EARTH

The primary purpose of texts, maps and photographs is to document works which occur in the landscape, evoking that which is formless or remote. If their character is that of feeding the imagination, the works that Long makes specifically for display in a gallery space feed the senses. They have an immediate, tangible physical presence. The mud works are executed directly on a wall; the indoor sculptures use natural

materials obtained locally. Both ways of working mirror Long's activities in the landscape. In the case of the sculpture, the connection between outdoor and indoor work is explicit. The mud works have no obvious counterpart in the landscape. This said, the use of mud connects directly with the works, using water alone, that Long makes in a natural setting. In a gallery space, mud makes the action of water and the rhythms of hand gestures visible and lasting. Mud is a natural bridge between water and stone, like fluid earth. Viewed in that light, a mud work – made rapidly and spontaneously – suggests a stone sculpture executed at lightning speed.

One of the mud works made for the present exhibition extends Long's engagement with ideas derived from Zen Bhuddism and also his recent use of Chinese hexagrams as the basis for works using mud. This new work is based on the I-Ching symbol for *Earth*. As such, the medium for the work of art is aligned with its meaning. Taken from the earth, the mud work now refers back to it. Echoing Chinese ideas about the reconciliation of opposites, it exists as a record of impermanence: energy made visible, order imposed on chaos, a trace of the artist's direct involvement with his materials.

As suggested by their splashes, drips and handmarks, such works are made freely and gesturally. They are nevertheless underpinned by principles of arrangement and order. Like the stones and sticks used in the sculptures, inert matter is drawn into a complex pattern or system. A mud work by Long is a *constructed* thing: its cumulative handmarks echoing the individual steps in a walk or the separate stones that comprise a sculpture made in a landscape. The relationships between constituent parts are vital in each of these activities. But as *Earth* suggests, in Long's work medium and meaning are closely interrelated. Beyond its formal characteristics, there lies a deeper significance.

Fundamental though the principle of arrangement is in Long's art, it is the singular character of the relationships created that carries meaning. In particular, the sense of *unity* expressed by these relationships is important. In the text work *River to River* 2001, displayed near the end of the present exhibition, a linking thread is drawn between three natural features – river, wood and tor – as the result of a walk on Dartmoor. The walk and the resulting text have imposed a pattern on these disparate elements. In another way, however, the work suggests that these natural features are *already* joined as part of an invisible and infinitely complex natural web. As such, the

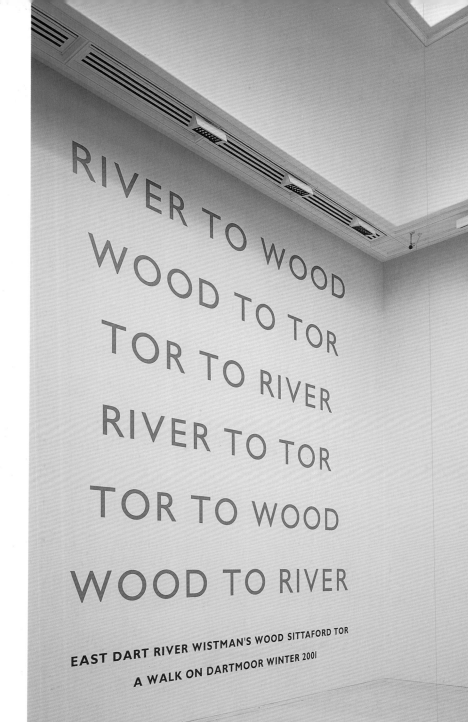

RIVER TO WOOD
WOOD TO TOR
TOR TO RIVER
RIVER TO TOR
TOR TO WOOD

WOOD TO RIVER

EAST DART RIVER WISTMAN'S WOOD SITTAFORD TOR
A WALK ON DARTMOOR WINTER 2001

RIVER
TO RIVER
2001

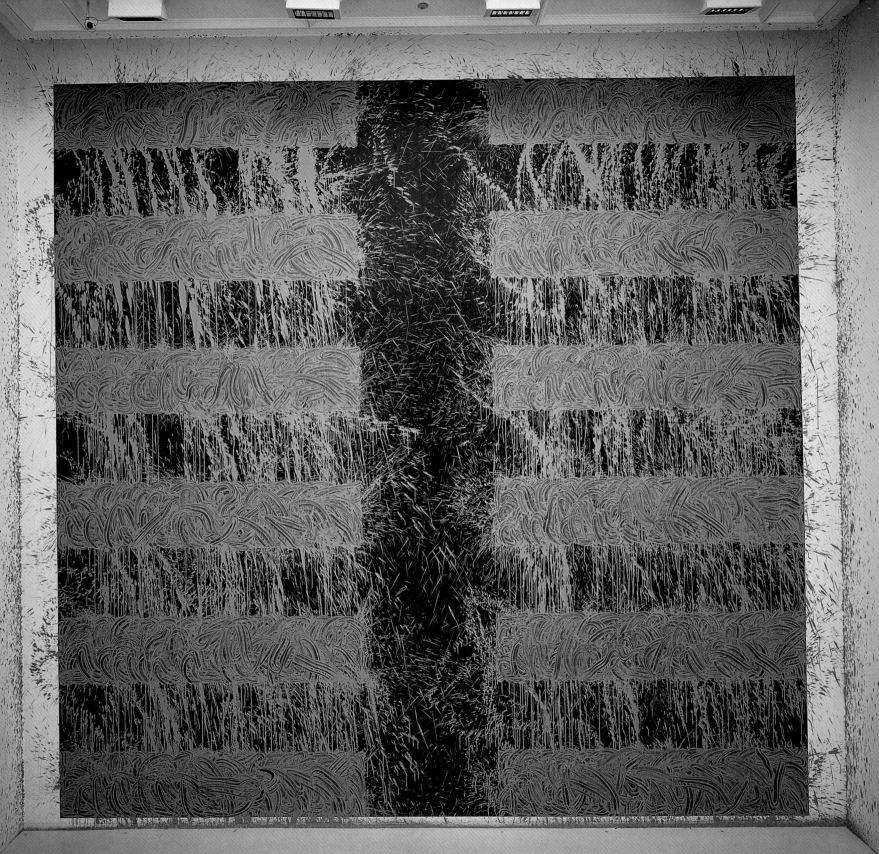

EARTH 2002

BEINN A'CHAIT
BEINN DEARG
ELRIG'IC AN TOISICH
BEINN GHARBH
BEINN BHREAC
AN SLIGEARNACH
MEALL ODHAR
ALLT DAMH DUBH
LEATHAD AN TAOBHAIN
CARN AN FHÌDLEIR LORGAIDH
SRÒN NA BAN-RIGH
CAOCHAN DUBH
RIVER FESHIE
ALLT A'CHAORAINN
SCARSOCH BHEAG
CNAPAN GARBH
BYNACK BURN
BRÀIGH COIRE CAOCHAN NAN LAOGH
CARN GREANNACH
AN SCARSOCH
SRÒN NA MACRANAICH
ALLT A'CHAORAINN
LEACHDANN FÉITH SEASGACHAIN
CARN EALAR
MEALL TIONAIL
GLAS FÉITH BHEAG
SRÒN GHARBH
GLAS FÉITH MHÒR
MEALL TIONAIL NA BEINNE BRICE
LOCH MHAIRC
CARN A'CHIARAIDH
BEINN MHEADHONACH
FÉITH AN LOCHAIN
AONACH NA CLOICHE MÓIRE
BRÀIGH NAN CREAGAN BREAC
BRÀIGH CLAIS DAIMH
CARN A'CHLAMAIN
BRÀIGH SRÒN GHORM
SRÒN DUBH
MEALL DUBH-CHLAIS
TARF WATER
FÉITH UAINE MHÒR
MEALL TIONAIL
CONLACH MHÒR
BRÀIGH COIRE NA CONLAICH
AN SLIGEARNACH
TARF WATER
CNAPAN NAN LAOGH
AN SGARSOCH
BYNACK BURN
CNAPAN GARBH
SCARSOCH BHEAG
ALLT A'CHAORAINN
MEALL TIONAIL
RIVER FESHIE
LEATHAD AN TAOBHAIN
CARN EALAR
LEACHDANN FÉITH SEASGACHAIN
BRÀIGH SRÒN GHORM
AONACH NA CLOICHE MÓIRE
CARN A'CHLAMAIN
BRÀIGH NAN CREAGAN BREAC
FÉITH AN LOCHAIN
BEINN MHEADHONACH
CARN A'CHIARAIDH
ELRIG'IC AN TOISICH
BEINN DEARG
BEINN BHREAC
BEINN DEARG
BEINN A'CHAIT

A 134 MILE MEANDERING WALK

SCOTLAND 1986

MIND MAP
DROPPINGS
RAVEN
EVERY STEP IS EQUAL
DRUMMING RAIN
FOLLOWING AN IDEA
NO TREES
GREY DOWN FEATHERS
SLUGS
WIND SILENCE
RIVER RISING AND FALLING IN THE NIGHT
SPRINGY FOOTSTEPS
MIST ALL DAY
FROM SOURCE TO MIDDAY
BROWSED HEATHER
DRINKING THE STREAM
BEES
FOLLOWING THE LIE OF THE LAND
FULL MOON TOUCHING THE HORIZON
PEAT
FROM CAMPSITE TO SOURCE
FOLLOWING A COMPASS BEARING
A GROUSE SITTING ON ONE EGG
DAY-WARMED RIVER WATER
NIGHT GROUND FROST
BONE
THE CALLS OF STARTLED GROUSE
MORNING STAR
HARES
SHIMMERING AIR
DEER TRAILS
DRY
SEA GULLS
FROGS
MIDSUMMER DAY
STEPPING-STONES MILESTONES
THE LINE OF A DAY'S WALK THE ARC OF THE SUN
FOX
OLD SLIPPERY ROOT
BRITTLE CARPETS OF WIND-STUNTED HEATHER
SCENT OF HEATHER
WATCHED BY DEER
MY SHADOW ALL DAY
ZIG-ZAGGING ACROSS A BOG
TRACE OF A KILL
MELTING SNOW-FIELD
BLEACHED ANTLER
MOTHS
COUNTLESS FORDINGS
DEEP DREAMING
WALKING A CIRCLE IN MIST
SMELL OF A ROTTING ANIMAL
EGGSHELL
THE WALKING UP EQUALS THE WALKING DOWN
DEER TRACKS
"BROKEN WING" DISPLAY BY A HEN PTARMIGAN
FOLLOWING A MAP
SPIDERS
SNOW-FLATTENED GRASS
MORNING RIVERBED AFTERNOON WATERSHED
CLOUDLESS
WET
FOLLOWING A DESIRE
DAWN CHORUS

TEN DAYS WALKING AND SLEEPING ON NATURAL GROUND

work of art is not just about imposing connections and order. Rather, there is a sense that it *reveals* a system of relationships: that it discloses a unity that already exists.

The idea of unified nature has antecedents in earlier art and philosophy. In the 19th century, the notion of the natural world – including man – as a single entity was a mainstay of Romantic thought. In *The Philosophy of Nature*, the influential German philosopher Schelling advanced the idea of nature evolving from matter into living things: plants, animals and humans. According to this view, everything is interrelated. The Romantic idea of the organic relation between man and nature has a resonance in Long's work. It would, however, be mistaken to over-emphasise the affinity with Romanticism. Long's art does not foreground emotion or indulge in flights of the imagination. It is grounded instead in the direct experience of the real world. Also, whereas the Romantics stressed the primacy of the individual in perceiving and interpreting nature, Long's work draws man and nature into balance, proportion and equilibrium.

Rather, the sense of order, unity and harmony in Long's work is the product of an approach that is essentially rationalist. While its innovatory means of expression are embedded in the art of the late 20th Century, its roots, if anything, are classical. In the ancient world, the relationship between man and nature was an abiding concern and the idea of order a passion. In Stoic philosophy, for example, human beings and nature were seen as the unified manifestation of the universal Mind. Consequently, the individual expressed his relationship with nature through the exercise of reason, which is a part of the universal Reason. As the Roman Emperor Marcus Aurelius (AD 121–180), who was versed in Stoic philosophy, observed: `an act that accords with nature is an act that accords with reason.'[4]

These principles find eloquent confirmation in Richard Long's art. Founded on a sense of deep accord with nature, his work expresses the beauty and fragility of this relationship. Involving direct interaction with nature and natural materials, its central means are rational and empirical. In the modern world, with a vastly expanded capacity for destruction, the relation of man and nature is as pressing and relevant as ever. For that reason, Long's art has a significance that is both timeless and universal.

Paul Moorhouse

Notes

1 Book Four, 40, trans. Maxwell Staniforth, London 1964, p73

2 Artist's statement, 2000

3 Ibid

4 *Meditations*, Book Seven, 11, op cit, p107

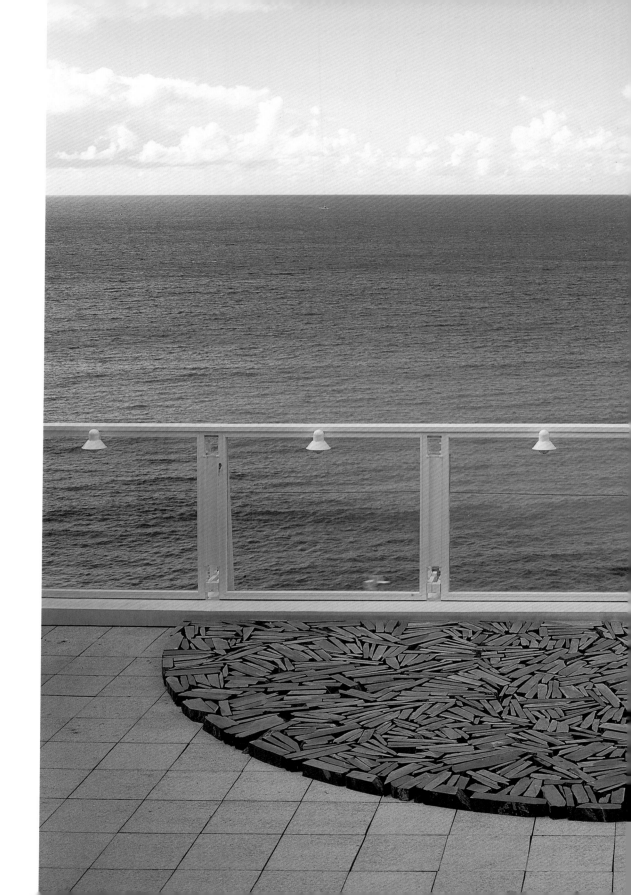

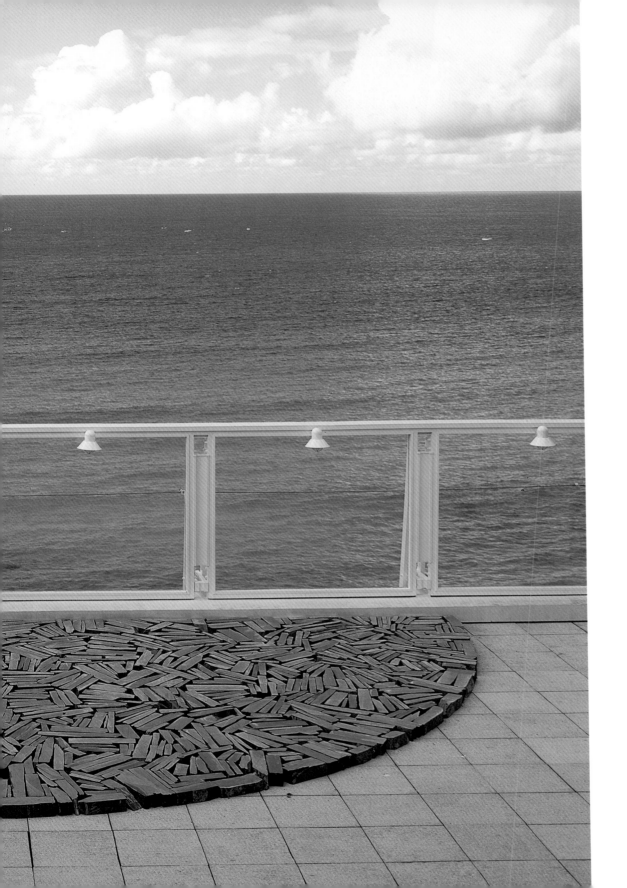

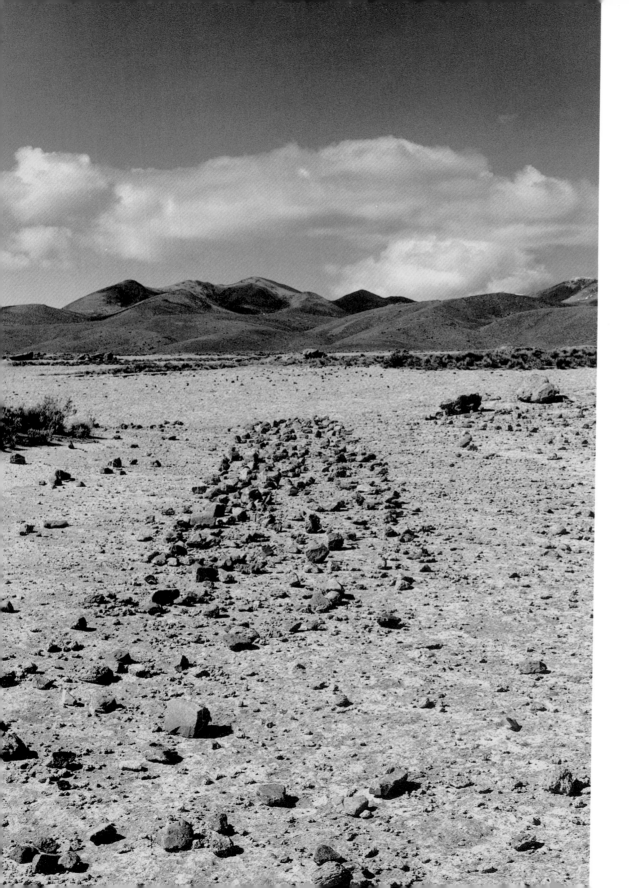

A LINE IN BOLIVIA

KICKED STONES

1981

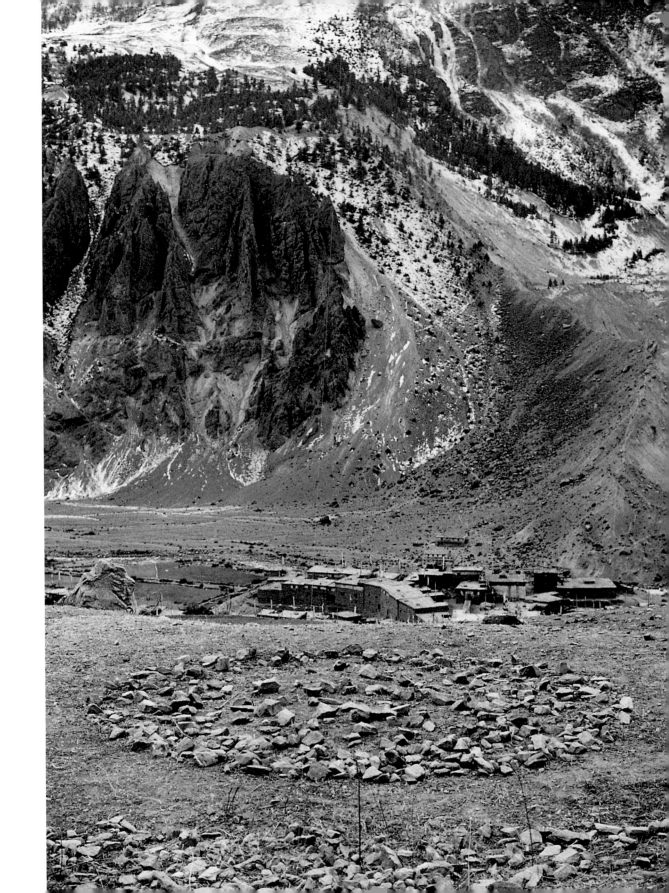

MANANG CIRCLE

A 21 DAY WALK IN NEPAL

1983

WALKING TO A LUNAR ECLIPSE

FROM A MIDDAY HIGH TIDE AT AVONMOUTH
A WALK OF 366 MILES IN 8 DAYS
ENDING AT A MIDNIGHT TOTAL ECLIPSE OF THE FULL MOON

A LEAP YEAR WALK ENGLAND 1996

WALKING TO A SOLAR ECLIPSE

STARTING FROM STONEHENGE

A WALK OF 235 MILES

ENDING ON A CORNISH HILLTOP

AT A TOTAL ECLIPSE OF THE SUN

1999

SUNRISE CIRCLE

SUNRISE AT 19,346 FEET

A CIRCLE DRAWN IN THE SNOW ON THE SUMMIT OF VOLCÁN COTOPAXI

ALONG A WALK OF 12 DAYS IN ECUADOR 1998

MIDWINTER NIGHT'S WALK

BY THE LIGHT OF A FULL MOON ON THE WINTER SOLSTICE

A WALK OF 16 HOURS FROM SUNSET TO SUNRISE

SOMERSET ENGLAND 1999

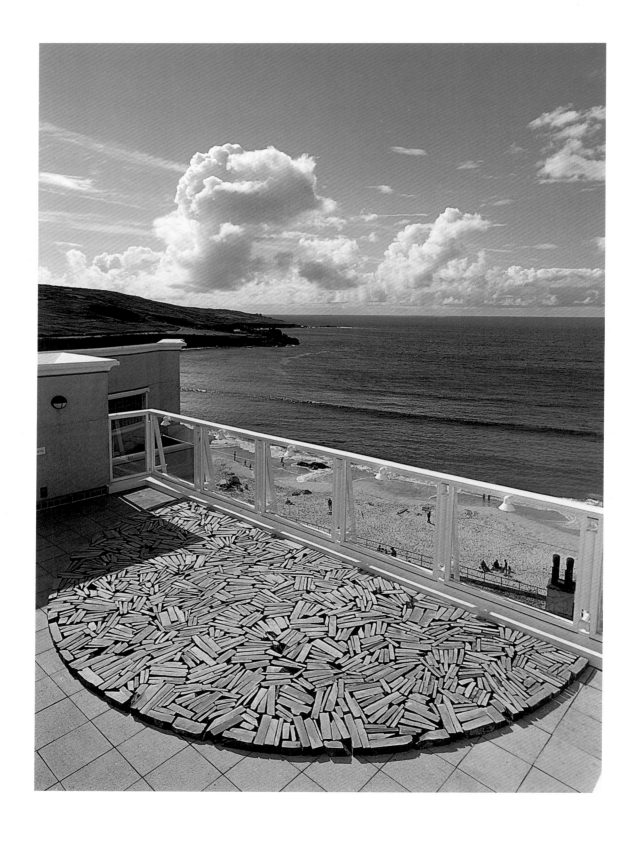

DUSTY TO MUDDY TO WINDY

A WALK OF 191 MILES IN 5 DAYS FROM BRISTOL TO TRURO

SNOWDROPS FAMILIAR ROADS FROM AVON INTO SOMERSET THE WELSH HILLS IN VIEW OVER THE MENDIPS
EXMOOR IN VIEW THE SOMERSET LEVELS THE LIGHTS OF FISHERMEN : HIGH TIDE ON THE RIVER PARRETT BLACK SMOCK INN

43 MILES

WATCHING BUZZARDS ACROSS THE BLACK DOWN HILLS INTO DEVON FOLLOWED BY A DOG
CLATTERING HOOVES ON THE ROAD QUIET WEATHER A NEW MOON THREE TUNS INN

41 MILES

DARTMOOR IN VIEW CROSSING THE RIVER EXE HEDGEROW DAFFODILS DUSTY LANES
UP ONTO DARTMOOR PASSING BENNETT'S CROSS AT DUSK THE HOOT OF AN OWL TWO BRIDGES

36 MILES

BODMIN MOOR IN VIEW DOWN OFF DARTMOOR CROSSING THE RIVER TAMAR INTO CORNWALL
FIVE HOURS OF RAIN ACROSS BODMIN MOOR IN MIST ORION BETWEEN RACING CLOUDS THE BARLEY SHEAF

40 MILES

MUDDY LANES FOLLOWING A HERD OF COWS CHINA CLAY TIPS KISSING GATE
ATLANTIC HORIZON A FOLLOWING WIND THE ROAD FLOODED ADMIRAL BOSCAWEN

31 MILES

ENGLAND 1993

ALL IRELAND WALK

THE GIANT'S CAUSEWAY

MINCE BEEF AND ONION PIES

RATHER YOU THAN ME

DRIZZLE

FIRST BIRD OF PREY

FAST CLOUDS

LAMBS

WASHING BAY

A WRONG FORK

POTATOES BLUES FOR SALE

SHARING A POT OF TEA AT A GARAGE

A REST IN A STRAW BARN

A WRONG FORK

IT'S A BEAUTIFUL MILD MORNING

DRIZZLE

B. D. FLOOD^{LTD} OLDCASTLE

SUPPER IN A KITCHEN BEING DECORATED

POTATOES PINKS FOR SALE

MAHON'S COSY SNUG

THE ROAD FLOODED

A COFFEE IN A FLOODED BAR THE SLIEVE BLOOM

THE ROAD FLOODED

OPEN TRENCHES AHEAD

WAITING WITH LOCALS FOR A MIDDAY OPENING

IT'S GOING TO BE BAD ALL DAY AND TOMORROW

WELCOME TO TIPPERARY TOWN

THE BALLYHOURA WAY

IT'S FROSTY THIS MORNING

POTHOLED ROAD

WRINGING OUT SOCKS IN A CHURCH

LONG'S BAR AND LOUNGE MALLOW

A CAMP IN THE BOGGERAGH MOUNTAINS

RAINBOW

THE ROAD FLOODED

FRIDAY MOUNTAIN BOG MEN

THE ROAD FLOODED

FOLLOWED BY A DOG FOR FIVE MILES

THE AHACRINDUFF RIVER IN SPATE

PLEASE LOOK FOR A LOOSE HORSE

A WRONG TURN

BALTIMORE BEACON

A WALK OF 382 MILES IN 12 DAYS FROM THE SOUTH COAST TO THE NORTH COAST OF IRELAND

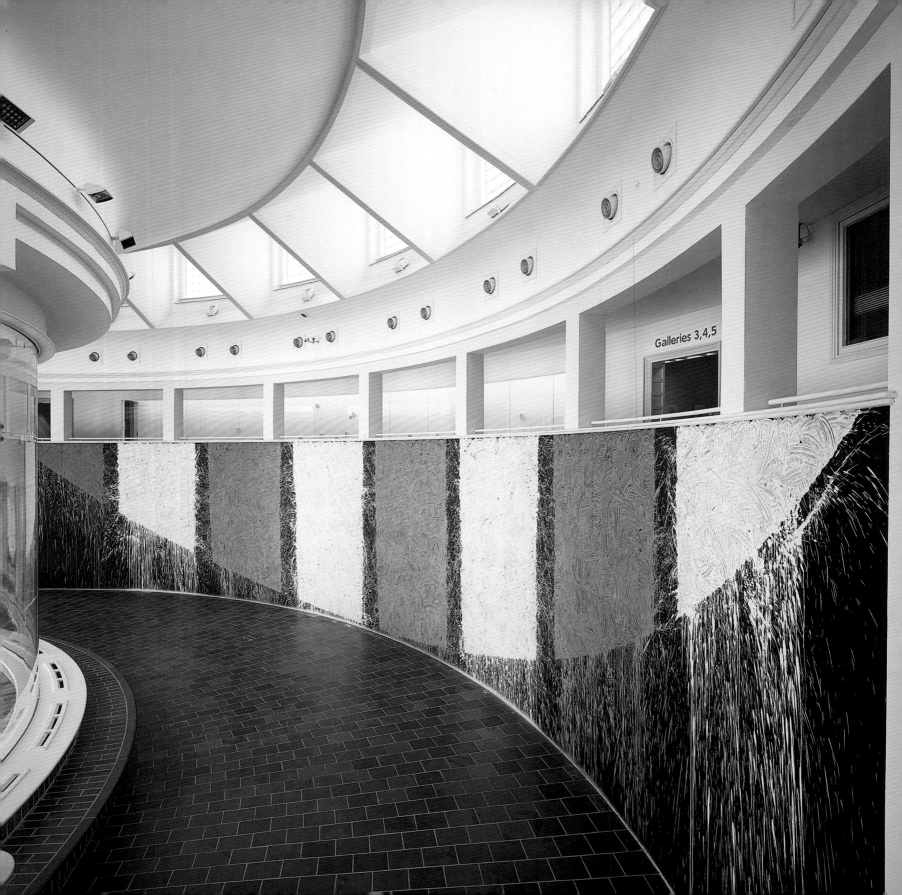

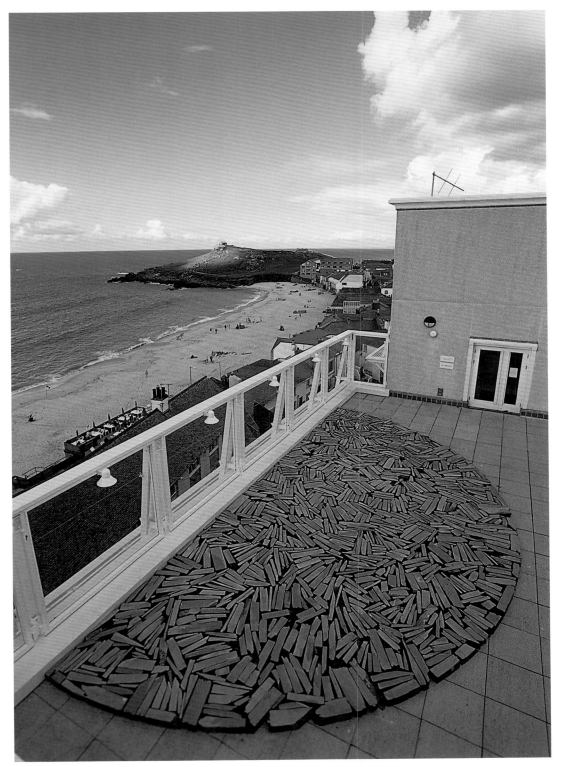

39

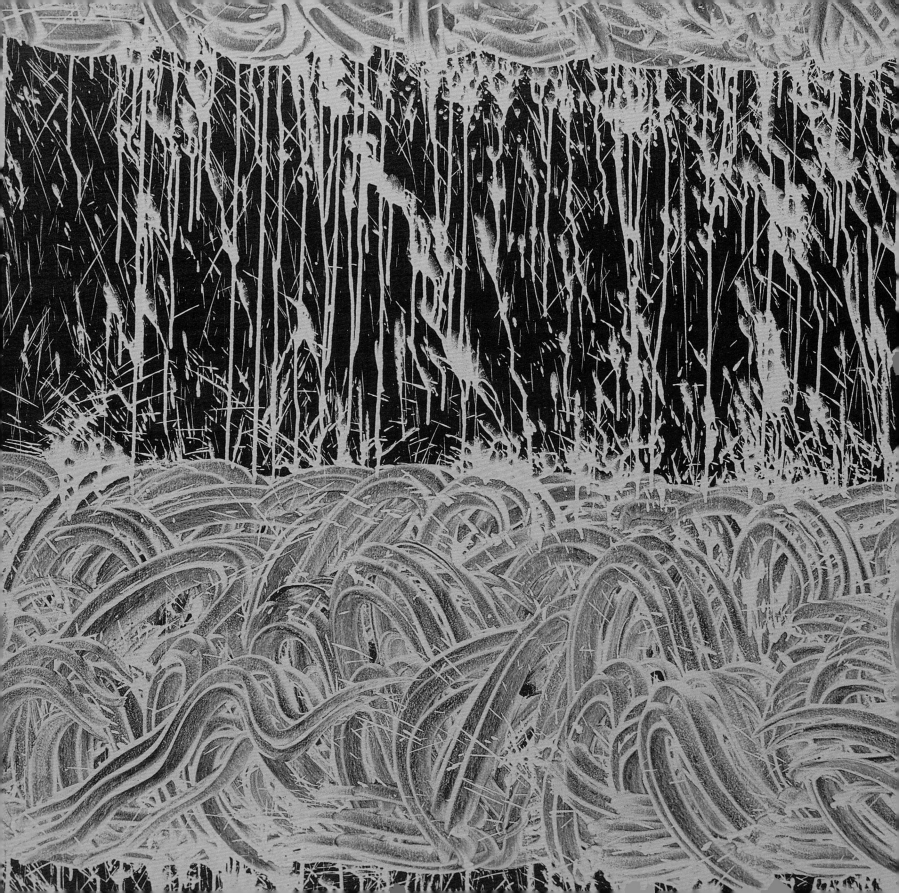

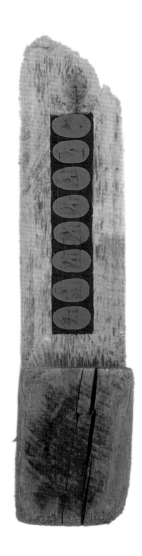

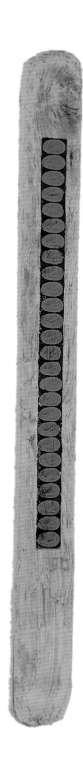

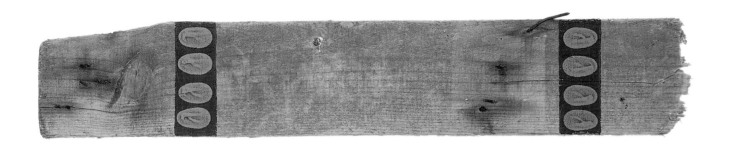

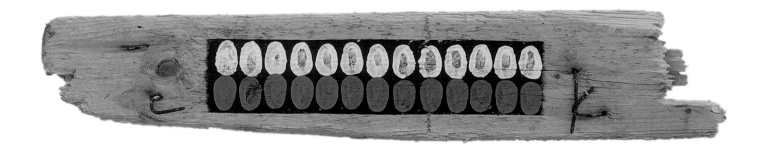

RICHARD LONG – SELECTED BIOGRAPHY

1945 Born in Bristol, England
1962–5 Studied at West of England
 College of Art, Bristol
1966–8 Studied at St. Martin's School
 of Art, London.

Lives and works in Bristol, U.K.

SOLO EXHIBITIONS

1968
Düsseldorf Konrad Fischer

1969
New York John Gibson Gallery
Düsseldorf Konrad Fischer
Krefeld Museum Haus Lange
Paris Galerie Yvon Lambert
Milan Lambert Gallery

1970
New York Dwan Gallery
Mönchengladbach Städtisches Museum
Düsseldorf Konrad Fischer

1971
Turin Gian Enzo Sperone
Oxford Museum of Modern Art
Amsterdam Art and Project

1972
London Whitechapel Art Gallery
New York Museum of Modern Art
 (Projects)
Paris Galerie Yvon Lambert

1973
Amsterdam Stedelijk Museum
Antwerp Wide White Space
Düsseldorf Konrad Fischer
London Lisson Gallery

1974
New York John Weber Gallery
Edinburgh Scottish National Gallery
 of Modern Art
London Lisson Gallery

1975
Düsseldorf Konrad Fischer
Antwerp Wide White Space
Paris Galerie Yvon Lambert
Amsterdam Art and Project
Basle Rolf Preisig Gallery
Plymouth Plymouth School of Art

1976
Rome Gian Enzo Sperone Gallery
Düsseldorf Konrad Fischer
Antwerp Wide White Space
London Lisson Gallery
Venice British Pavilion, Venice
 Biennale
Tokyo Art Agency Tokyo
Bristol Arnolfini
New York Sperone Westwater Fischer
 Gallery

1977
London Whitechapel Art Gallery
Amsterdam Art and Project

Poznan Gallery Akumalatory
Basle Rolf Preisig Gallery
London Lisson Gallery
Berne Kunsthalle
Melbourne National Gallery of Victoria
Sydney Art Gallery of New South Wales

1978
Amsterdam Art and Project
Paris Galerie Yvon Lambert
Düsseldorf Konrad Fischer
London Lisson Gallery
Leeds Park Square Gallery
New York Sperone Westwater Fischer
 Gallery
Hamburg Austellungsraum Ulrich
 Ruckriem

1979
Zurich Ink Gallery
London Anthony d'Offay Gallery
Basle Rolf Preisig Gallery
Londonderry Orchard Gallery
Southampton Photographic Gallery,
 Southampton University
Eindhoven Stedelijk van Abbemuseum
London Lisson Gallery
Tokyo Art Agency Tokyo
Oxford Museum of Modern Art

1980
Athens Karen and Jean Bernier Gallery
Amsterdam Art and Project
Cambridge Fogg Art Museum, Harvard
 University

New York	Sperone Westwater Fischer Gallery
London	Anthony d'Offay Gallery
Düsseldorf	Konrad Fischer

1981

New York	Sperone Westwater Fischer Gallery
Edinburgh	Graeme Murray Gallery
Düsseldorf	Konrad Fischer
London	Anthony d'Offay Gallery
Toronto	David Bellman Gallery
Bordeaux	CAPC, Musée d'Art Contemporain de Bordeaux

1982

Amsterdam	Art and Project
Paris	Galerie Yvon Lambert
Los Angeles	Flow Ace Gallery
New York	Sperone Westwater Fischer Gallery
Ottawa	National Gallery of Canada

1983

Toronto	David Bellman Gallery
Bristol	Arnolfini
London	Anthony d'Offay Gallery
Turin	Galleria Tucci Russo
Tokyo	Art Agency Tokyo
Tokyo	Century Cultural Centre
Düsseldorf	Konrad Fischer

1984

London	Coracle Press
Naples	Lucio Amelio Gallery
Paris	Gallery Crousel-Hussenot
Athens	Jean Bernier Gallery
New York	Sperone Westwater Gallery
Dallas	Dallas Museum of Art

Kilkenny	The Butler Gallery, Kilkenny Castle
Londonderry	Orchard Gallery
London	Anthony d'Offay Gallery
Düsseldorf	Konrad Fischer

1985

Basle	Gallery Buchmann
London	Anthony d'Offay Gallery
Kendal	Abbot Hall
Malmö	Malmö Konsthall
Milan	Padiglione d'Arte Contemporanea

1986

Madrid	Palacio de Cristal
Paris	Galerie Crousel-Hussenot
New York	Solomon R. Guggenheim Museum
New York	Sperone Westwater Gallery
London	Anthony d'Offay Gallery
Pori, Finland	Porin Taidemuseo
Turin	Galleria Tucci Russo

1987

Geneva	Musée Rath
Liverpool	Coracle Atlantic Foundation, Renshaw Hall
Chicago	Donald Young Gallery
Nailsworth	Cairn Gallery
Grenoble	Magasin, Centre National d'Art Contemporain de Grenoble
Athens	Jean Bernier Gallery

1988

Düsseldorf	Konrad Fischer
Aachen	Neue Galerie-Summlung Ludwig
London	Anthony d'Offay Gallery

1989

St Gallen	Kunstverein St Gallen
Athens	Jean Bernier Gallery
Turin	Galleria Tucci Russo
Bristol	Coopers Gallery
New York	Sperone Westwater Gallery
Bristol	Bristol Old Vic Theatre
Chagny	Pietro Sparta Gallery
La Jolla	La Jolla Museum of Contemporary Art
Halifax	Henry Moore Sculpture Trust Studio, Dean Clough

1990

Bristol	Arnolfini
London	Anthony d'Offay Gallery
Los Angeles	Angles Gallery
Glarus	Galerie Tschudi
Düsseldorf	Konrad Fischer
London	Tate Gallery
Stockholm	Magazine 3 Konsthall
Rochechouart	Château de Rochechouart

1991

Liverpool	Tate Gallery
Frankfurt	St Delsches Kunstinstitut und Städtische Galerie
London	Hayward Gallery
Turin	Galleria Tucci Russo
New York	Sperone Westwater Gallery
Edinburgh	Scottish National Gallery of Modern Art
Glarus	Galerie Tschudi

1992

Athens	Jean Bernier Gallery
Los Angeles	Angles Gallery
Warwick	Mead Gallery, University of Warwick

Barcelona Fundacio Espai Poblenou
Düsseldorf Konrad Fischer

1993
New York 65 Thompsom Street
Paris ARC, Musée d'Art Moderne
 de la Ville de Paris
Seoul Inkong Gallery
London Anthony d'Offay Gallery
Bremerhaven Kunstverein Bremerhaven
Santa Fe Centre for Contemporary Arts
Bremen Newen Museum Weserburg
Glarus Galerie Tschudi
New York Sperone Westwater Gallery

1994
Düsseldorf Kunstsammlung Nordrhein
 Westfalen
New York New York Public Library
Düsseldorf Konrad Fischer
New York Sperone Westwater Gallery
Philadelphia Philadelphia Museum of Art
Rome Palazzo Delle Esposizioni
Santa Fe Centre for Contemporary Arts
Orkney Pier Arts Centre
São Paulo São Paulo Bienal
Sydney Museum of Contemporary Art
Sydney Sherman Galleries
Torre Pellice Galleria Tucci Russo
Huesca Sala de Exposiciones de la
 Diputacion de Huesca

1995
Bünde Bündner Kunstverein and
 Bündner Kunstmuseum
New York Peter Blum, Blumarts Inc
Santa Fe Laura Carpenter Fine Art

London Anthony d'Offay Gallery
Glarus Galerie Tschudi
Düsseldorf Konrad Fischer
Reykjavik Syningarsalur
San Francisco Daniel Weinburg Gallery

1996
Tokyo Setagaya Art Museum
Kyoto National Museum of Modern
 Art
Exeter Spacex Gallery
Bolzano AR/GE KUNST Galerie
 Museum
Glarus Galerie Tschudi
Houston Contemporary Arts Museum
Fort Worth Modern Art Museum of Fort
 Worth

1997
Duisburg Wilhelm Lehmbruck Museum
St Andrews Crawford Arts Centre
Naoshima Benesse Museum of
 Contemporary Art
New York Sperone Westwater Gallery
Bristol Bristol City Museum and Art
 Gallery
Palermo Spazio Zero, Cantieri Culturali
 'La Zisa

1998
Zugspitze 'kunst auf der zugspitze'
London Anthony d'Offay Gallery
Wakefield Yorkshire Sculpture Park,
 Bretton Hall
Glarus Galerie Tschudi
Torino Tucci Russo

1999
Hannover Kunstverein Hannover
Athens Bernier/Eliades
Braga Mario Sequeira Gallery

2000
Venice, California Griffin Contemporary, USA
London Anthony d'Offay Gallery
New York Sperone Westwater Gallery
New York James Cohan Gallery
New York Public Art Fund Projects at
 Seagram Plaza, Doris C.
 Freedman Plaza and on the
 subway trains
Bristol Royal West of England Academy
Bilbao, Spain Guggenheim Bilbao
Schloss Leuk Leuk-Stadt, Switzerland
Trento, Italy Museo di Arte Moderna e
 Contemporanea di Trento e
 Rovereto
Dusseldorf Konrad Fischer
Glarus Galerie Tschudi

2001
Kleve Museum Kurhaus,
Paris Galerie Daniel Templon
Porto Museu Serralves
Milwaukee Milwaukee Art Museum

2002
Glarus Galerie Tschudi
Los Angeles Griffin Contemporary
Darmstadt Hessisches Landesmuseum
Salisbury New Art Centre and Sculpture
 Park & Gallery at Roche Court
St Ives Tate St Ives